Gothic Girls

Halloween Activity Book

by Tabz Jones

Books by Tabz Jones

Digital Landscape Adult Coloring Book	Darling Dolls	Fantasy Fae Adult Coloring Book
Fantasy Art Mini Adult Coloring Book	Fantastic Creatures	Fractal Art Adult Coloring Book Volumes 1-2
Sun and Sand Adult Coloring Book	Gothic Girls Art Book	In Loving Memory Churchyard Adult Coloring Book
Gothic Fairy Dream Journal	Rose Cross Dream Journal	Fantasy Art Adult Coloring Book Volumes 1-2
Rockabilly Roses Journal	Reflections Vampire Poetry	Doodle Monsters Adult Coloring Book
Dark Matter Adult Coloring Book	Steampunk Adult Coloring Book	Summer Flowers Adult Coloring Book
Gothic Girls Adult Coloring Book Volumes 1-7	Angelic Book of Shadows	Skullz Adult Coloring Book Volumes 1-2
Dangerous Curves Adult Coloring Book	Fantastic Creatures	Dark Fantasy Adult Coloring Book Volumes 1-3
Fantasy Men Adult Coloring Book		Classic Swears Adult Coloring Book Standard and Mini Editions
Harlequinn Pastel Fantasy Dream Journal		Statuesque Adult Coloring Book
Gothiscopic Kaleidoscopes Coloring Book		

Copyright © 2016 by Tabz Jones

All rights reserved. This book or any portion thereof

may not be reproduced or used in any manner whatsoever

without the express written permission of the author

except for the use of brief quotations in a book review.

Printed in the United States of America

First Printing, 2016

ISBN-13: 978-1537078847

ISBN-10: 1537078844

Tabz Jones

PO BOX 2137

Alma AR 72921

www.gothictoggs.net

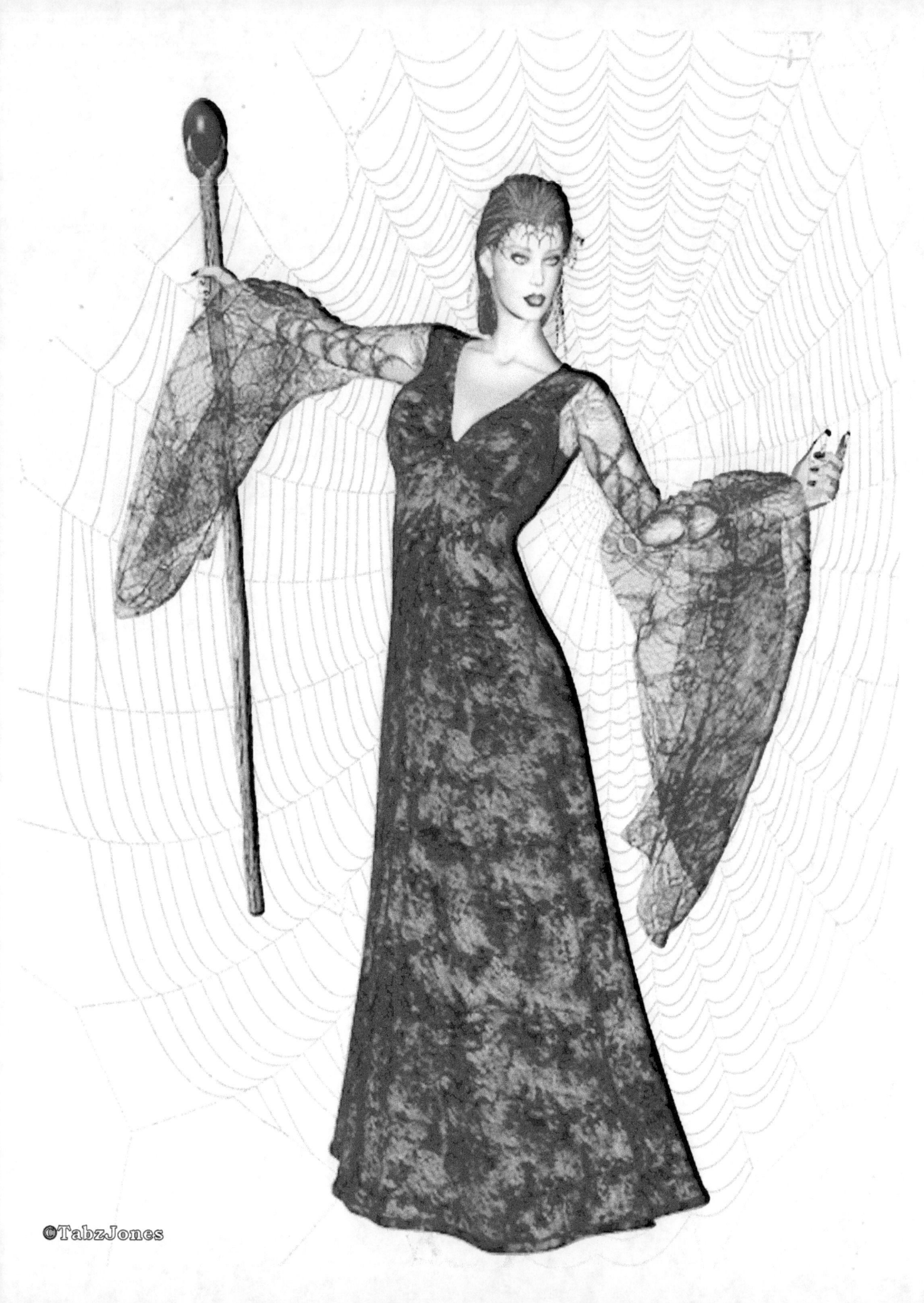

hllwoaene _____

kpnsmupi _____

ycand _____

sctouem _____

shgot _____

somnters _____

iamerpvs _____

iwctseh _____

cereemty _____

tkairertrtoc _____

©TabzJones

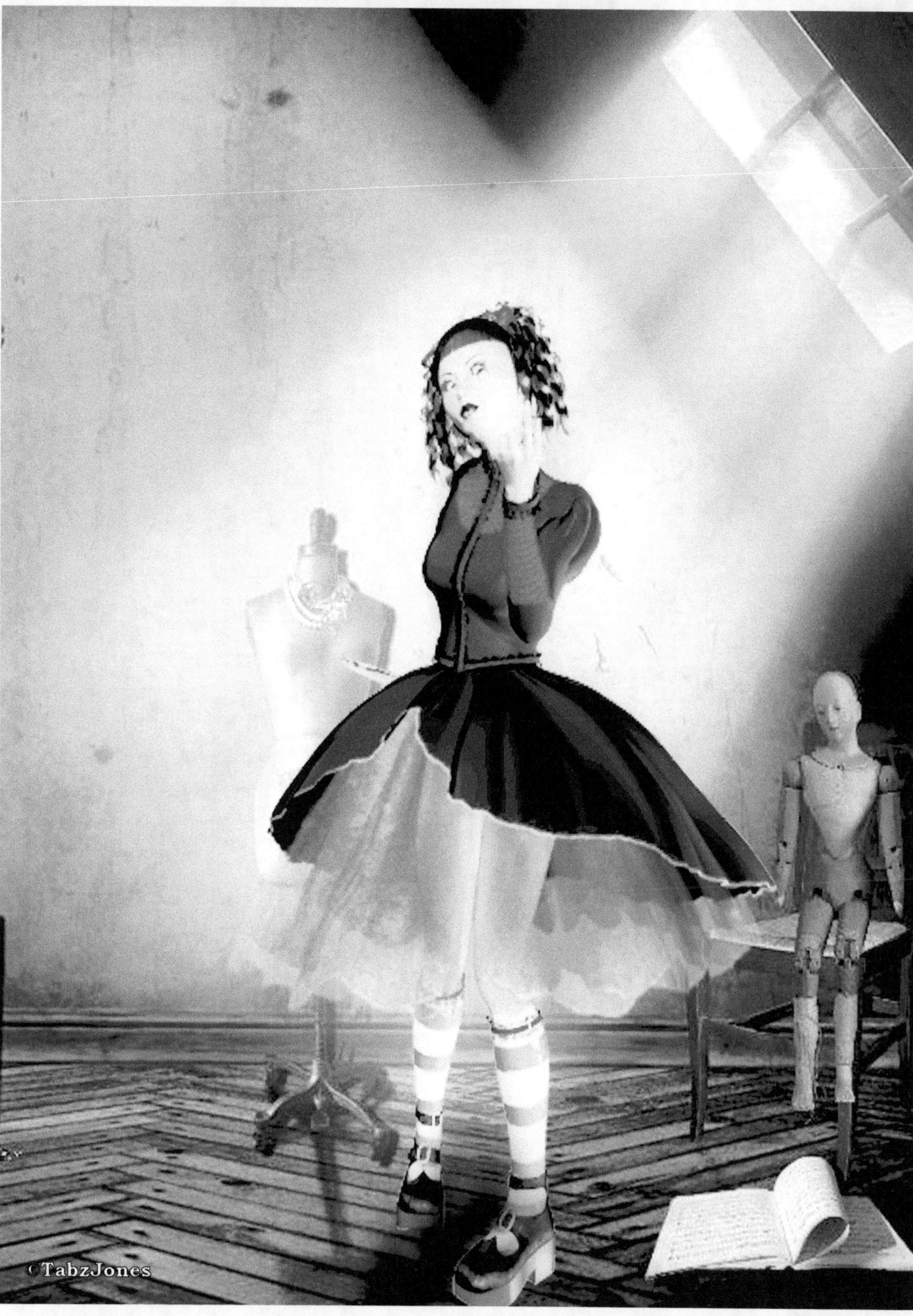

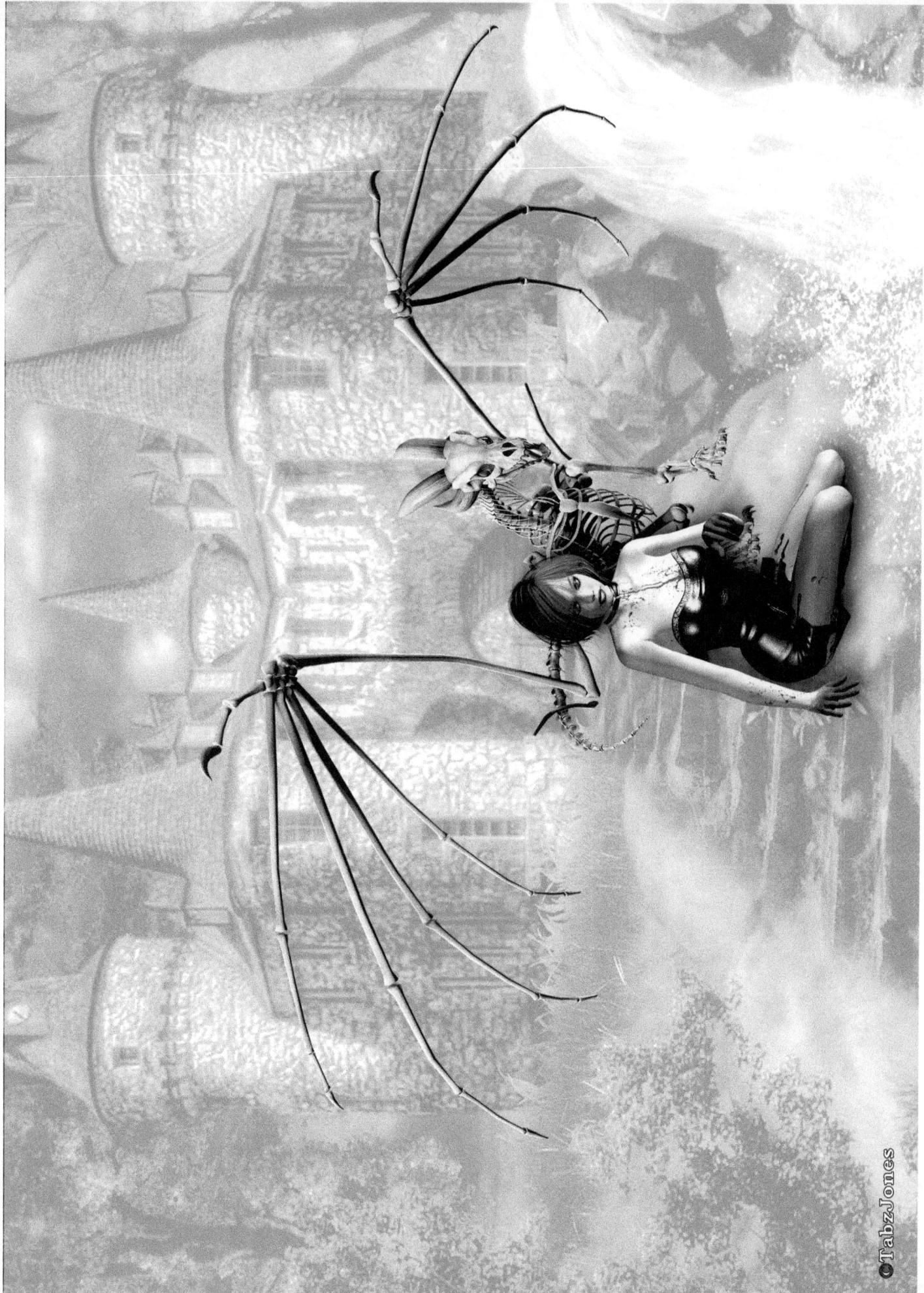

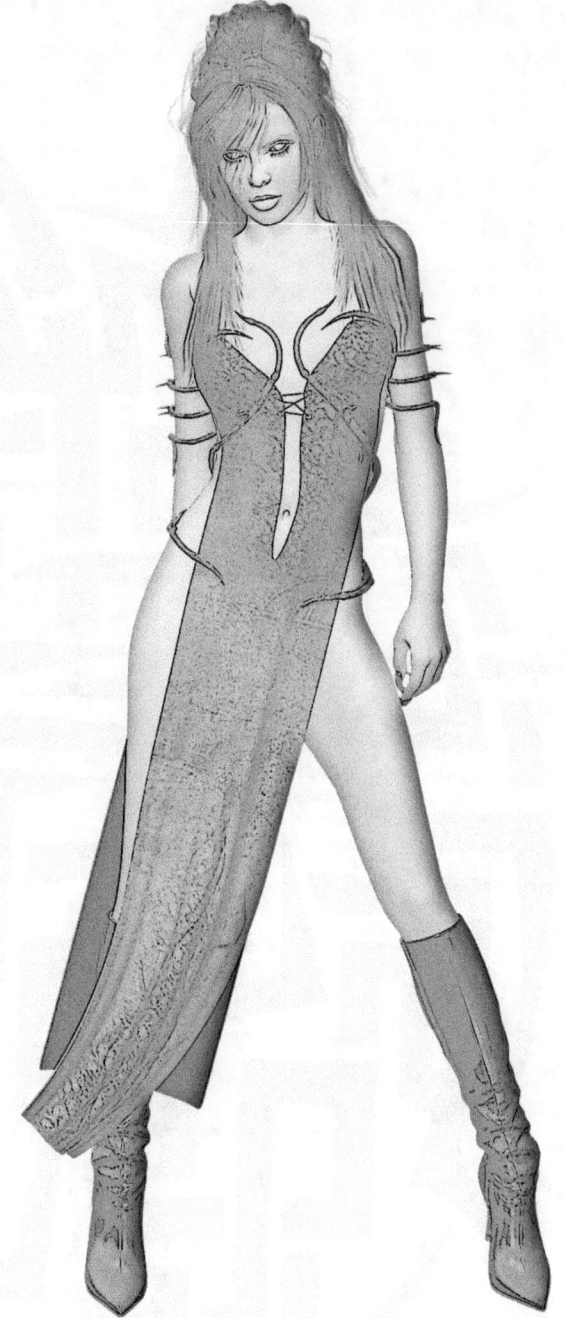

Across
2. symbol of eternal life
3. becoming a vampire
6. too hot to handle
8. half vampire half human
9. not a favorite accessory
11. a fast food restaurant
12. someone who kills vampires

Down
1. a vampiric person
4. where to find a vampire
5. white wine to a vampire
7. totally allergic to this
10. how to kill a vampire
11. a vampire's girlfriend

©TabzJones

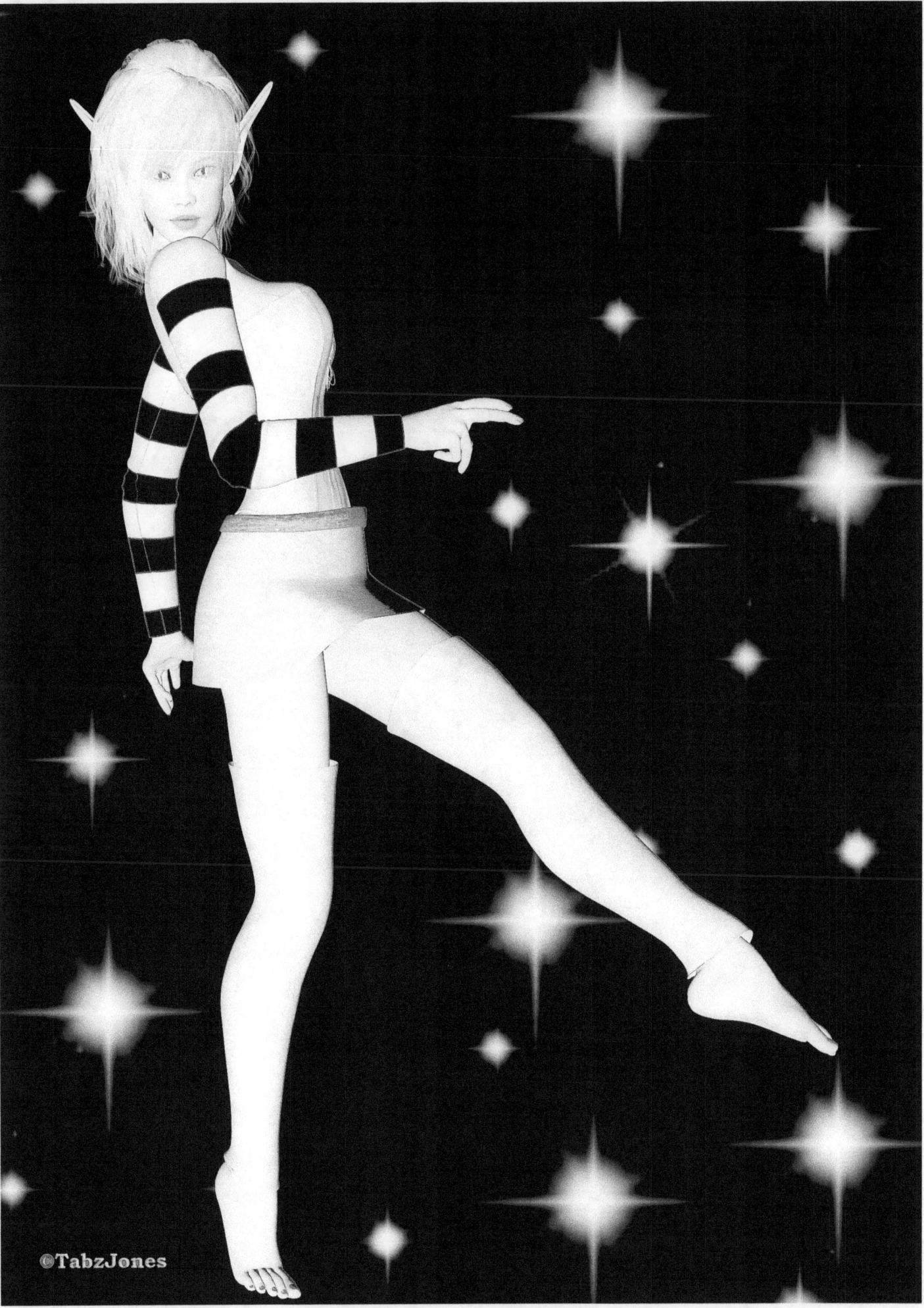

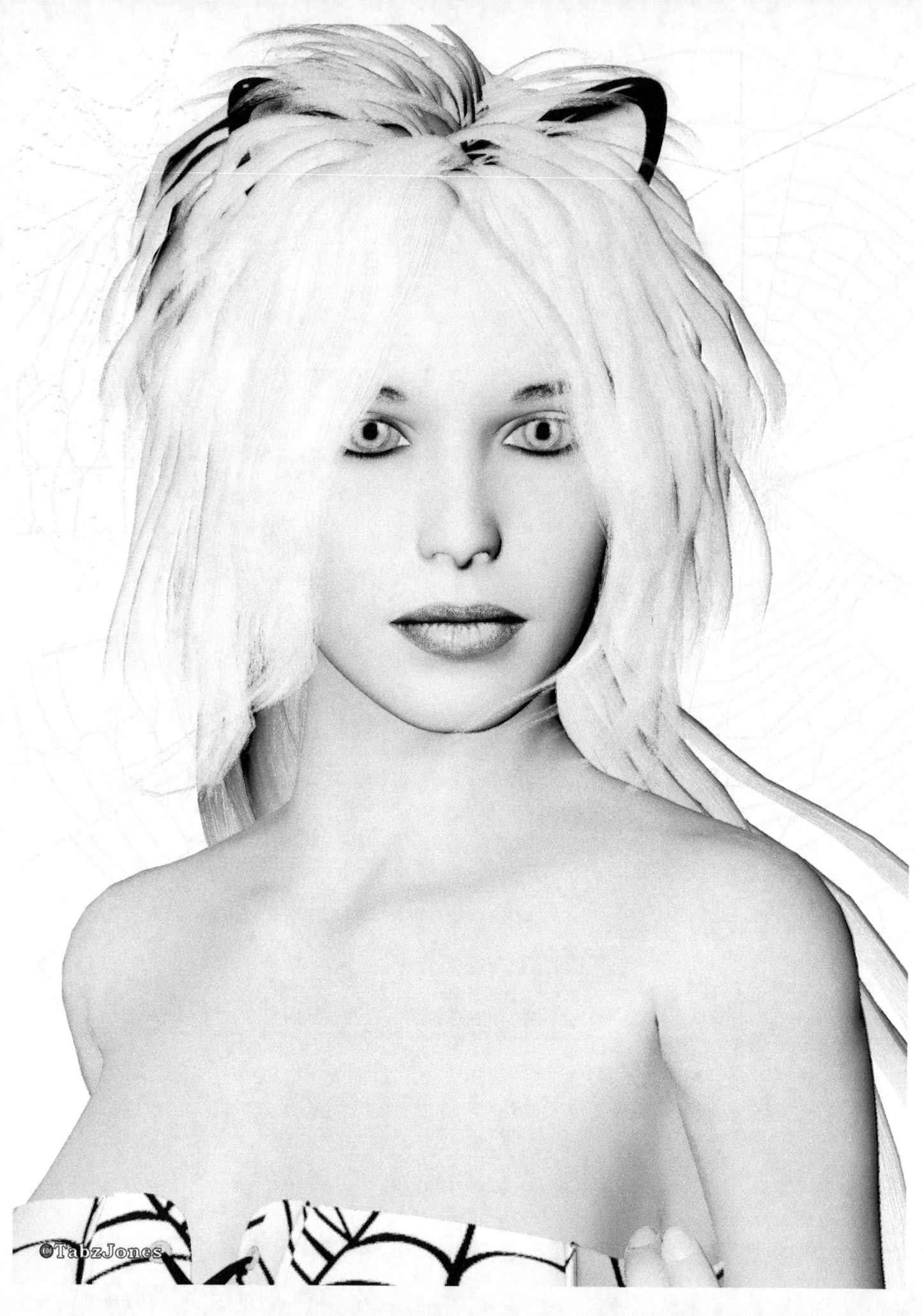

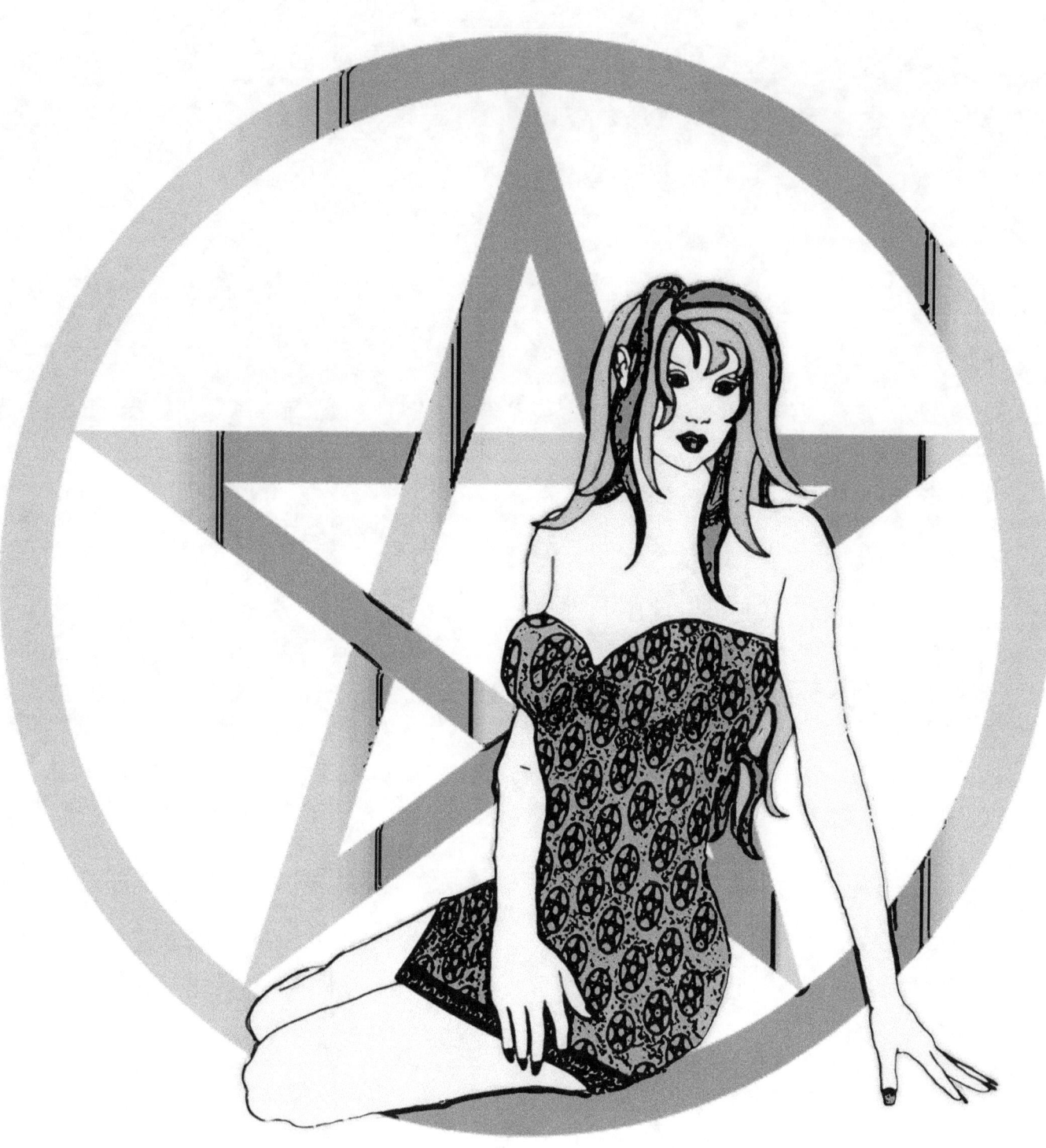

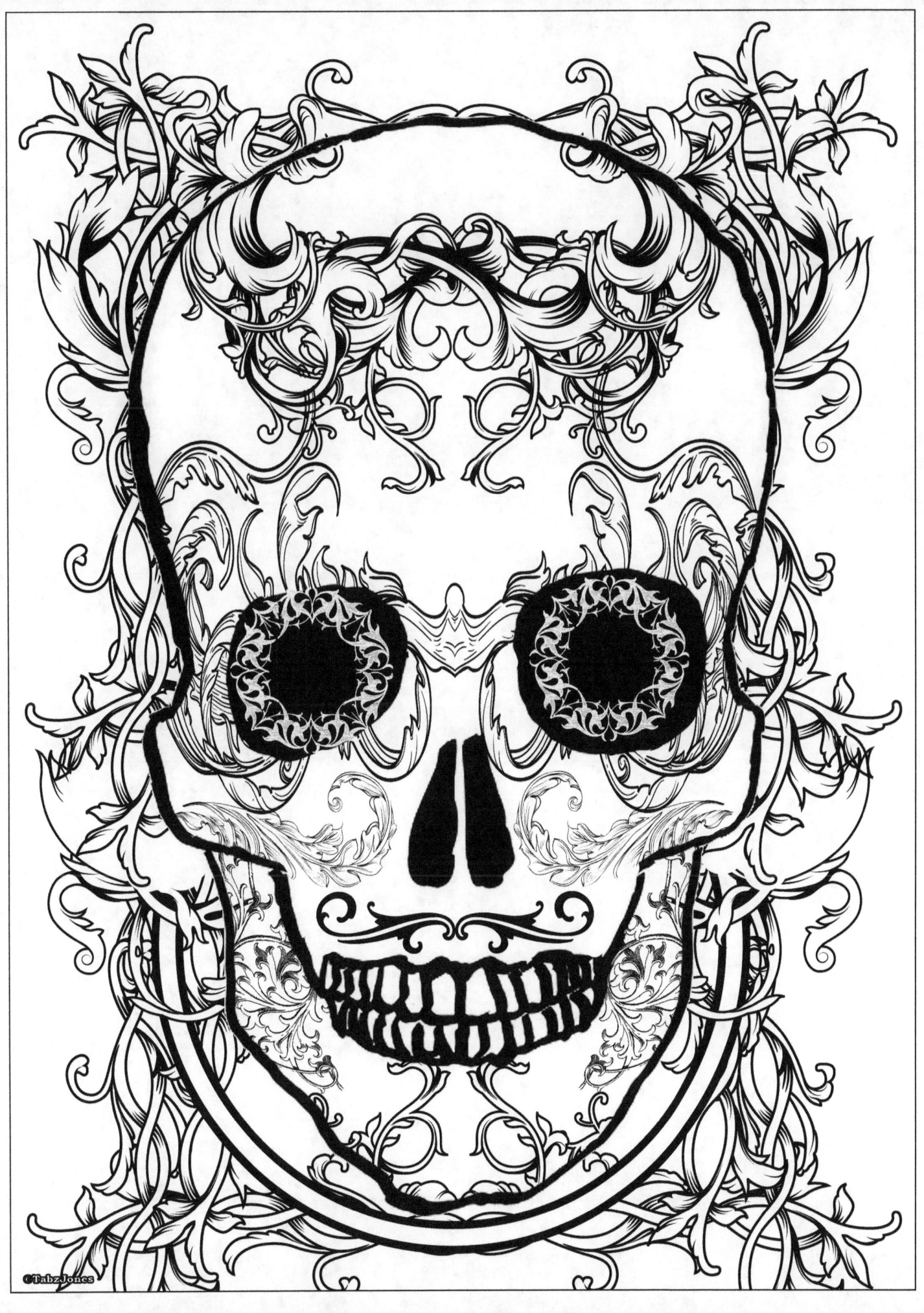

Witchy Ways

- ASTRAL
- CAULDRON
- CIRCLE
- COVEN
- CRONE
- FAMILIAR
- HANDFASTING
- MAIDEN
- MEDITATION
- MOTHER
- OLDWAYS
- PAGAN
- PENTACLE
- SABBAT
- SAMHAIN
- SPELLS
- SPIRITUAL
- SUMMERLAND
- WICCA
- WITCH
- WITCHCRAFT
- YULE

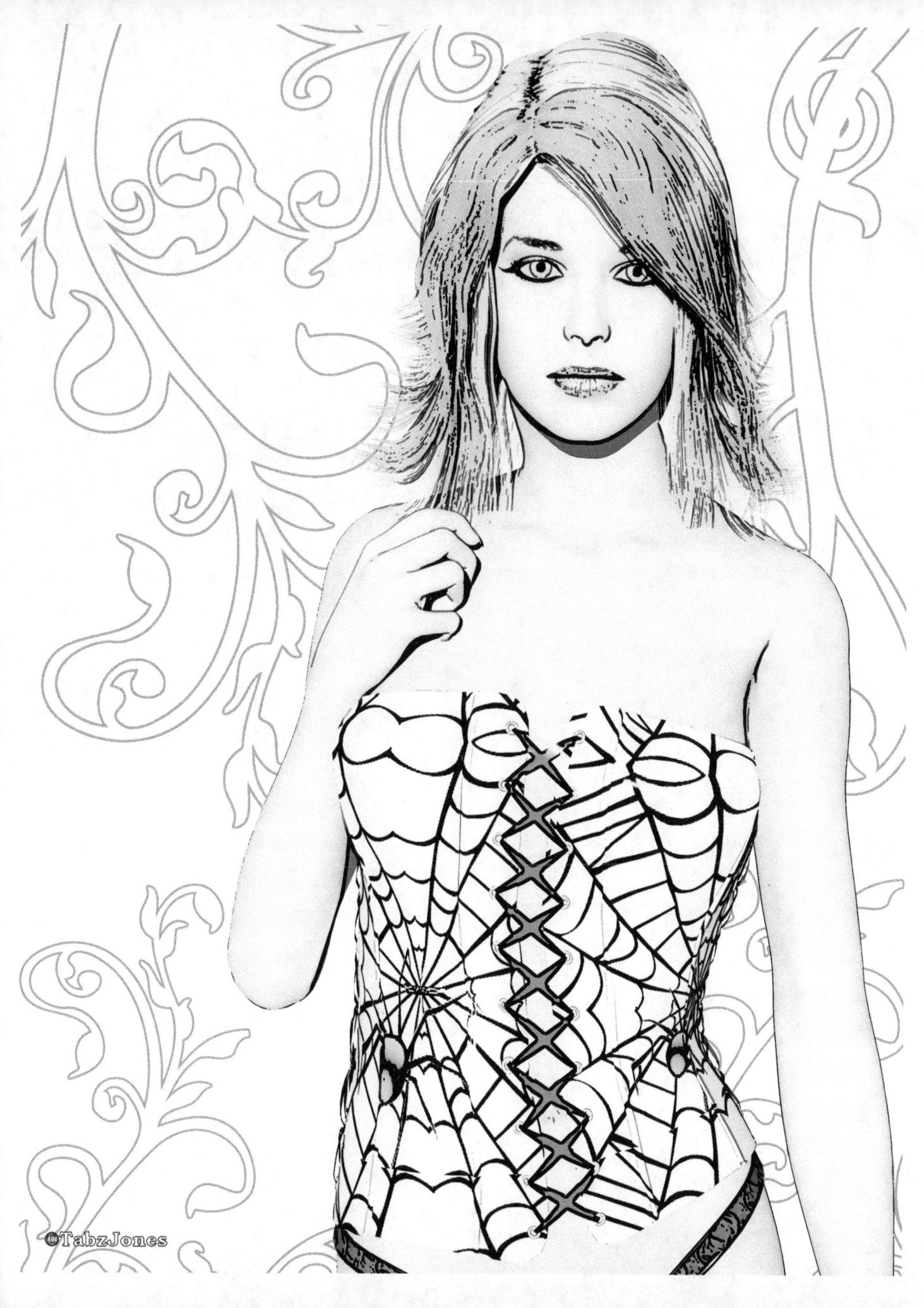

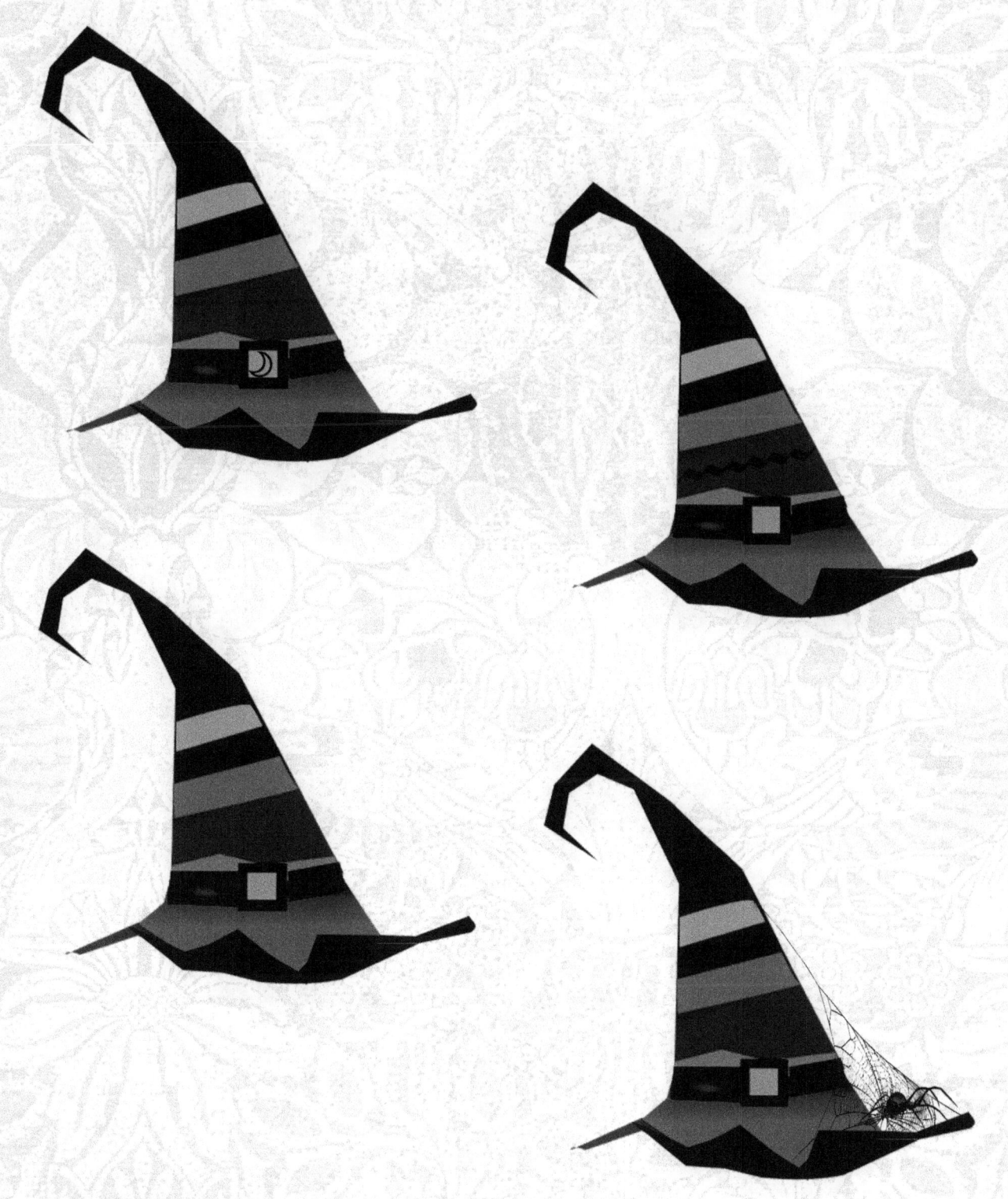

Which Witch is Which?
Can you spot the differences

©TabzJones

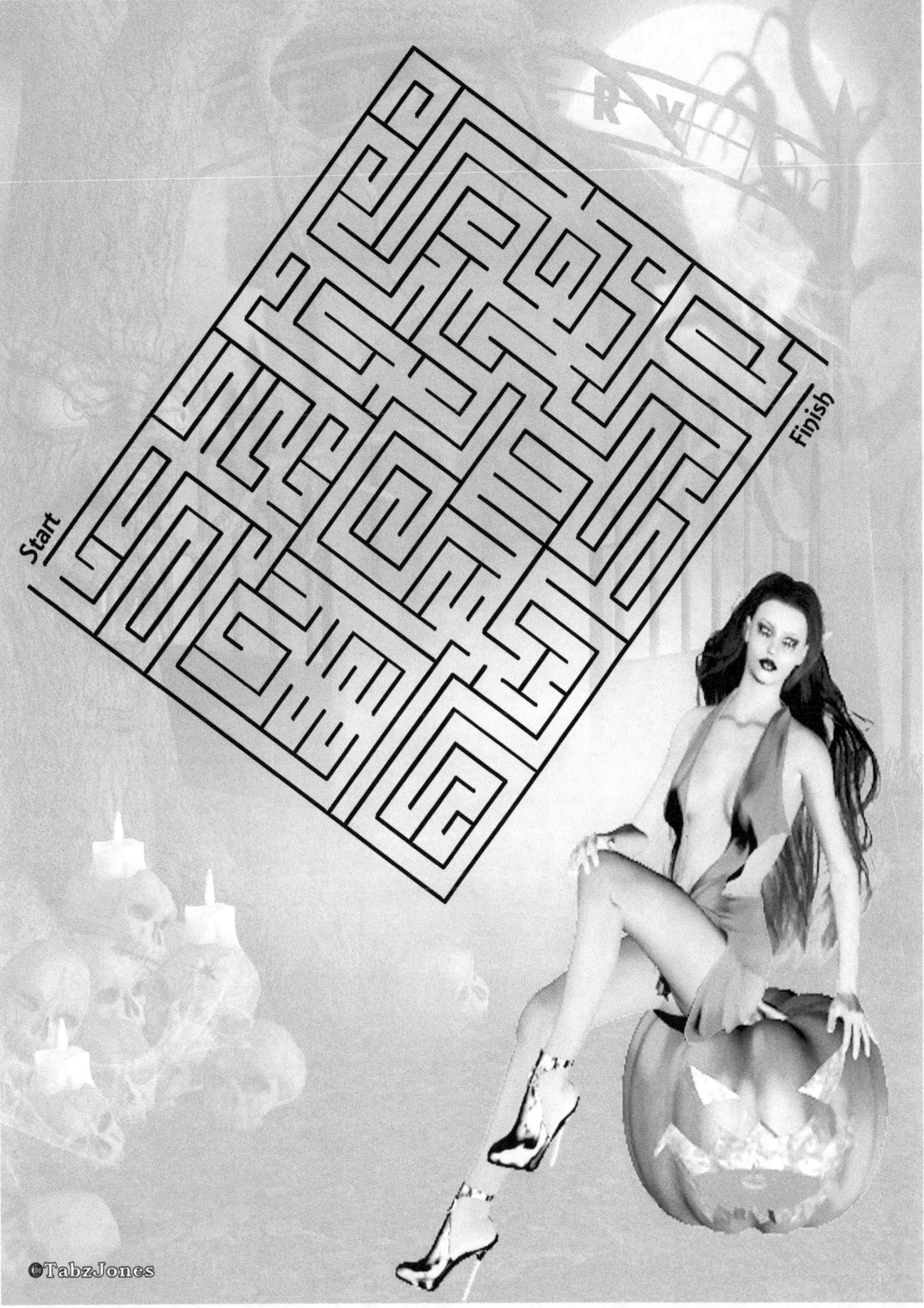

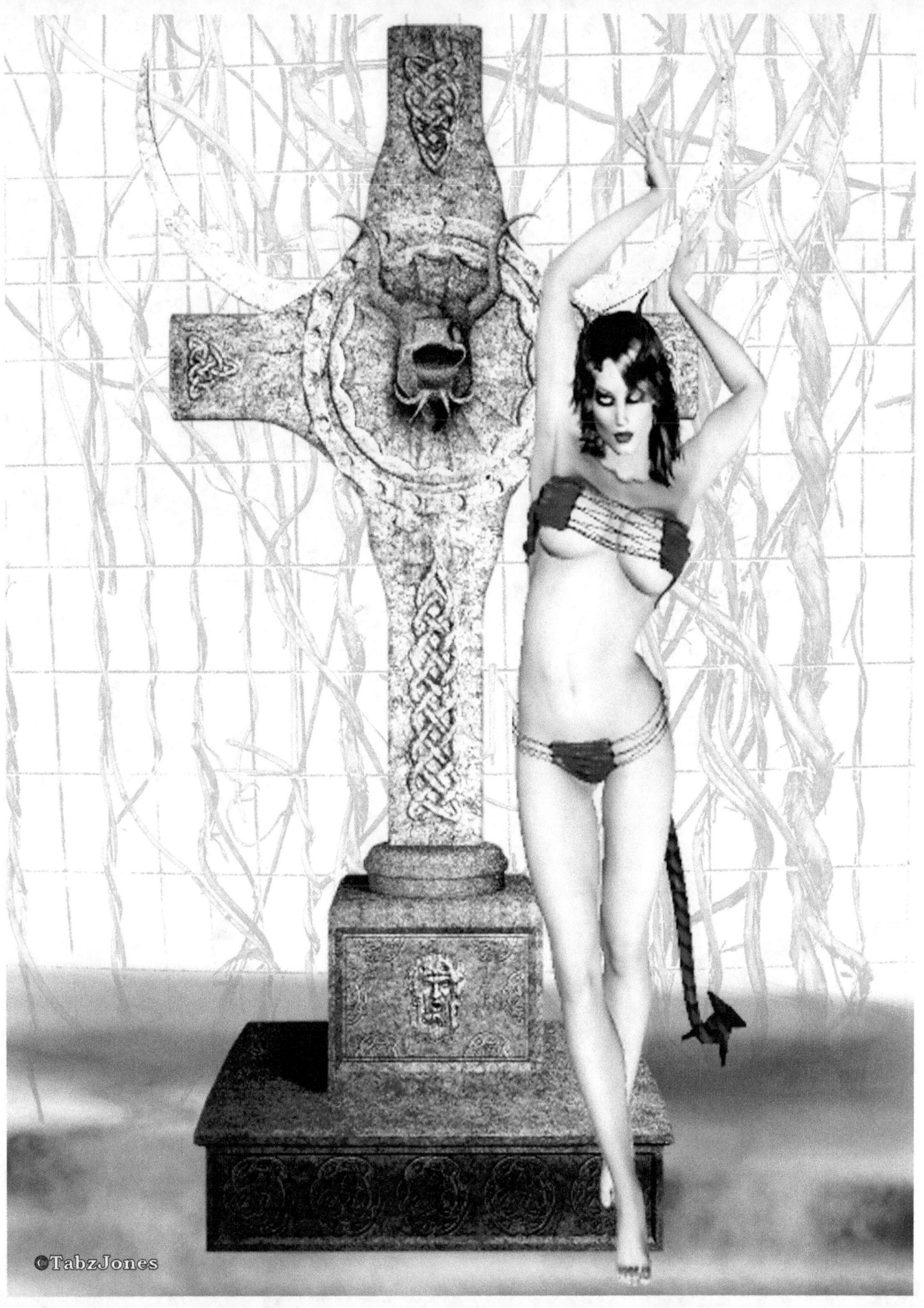

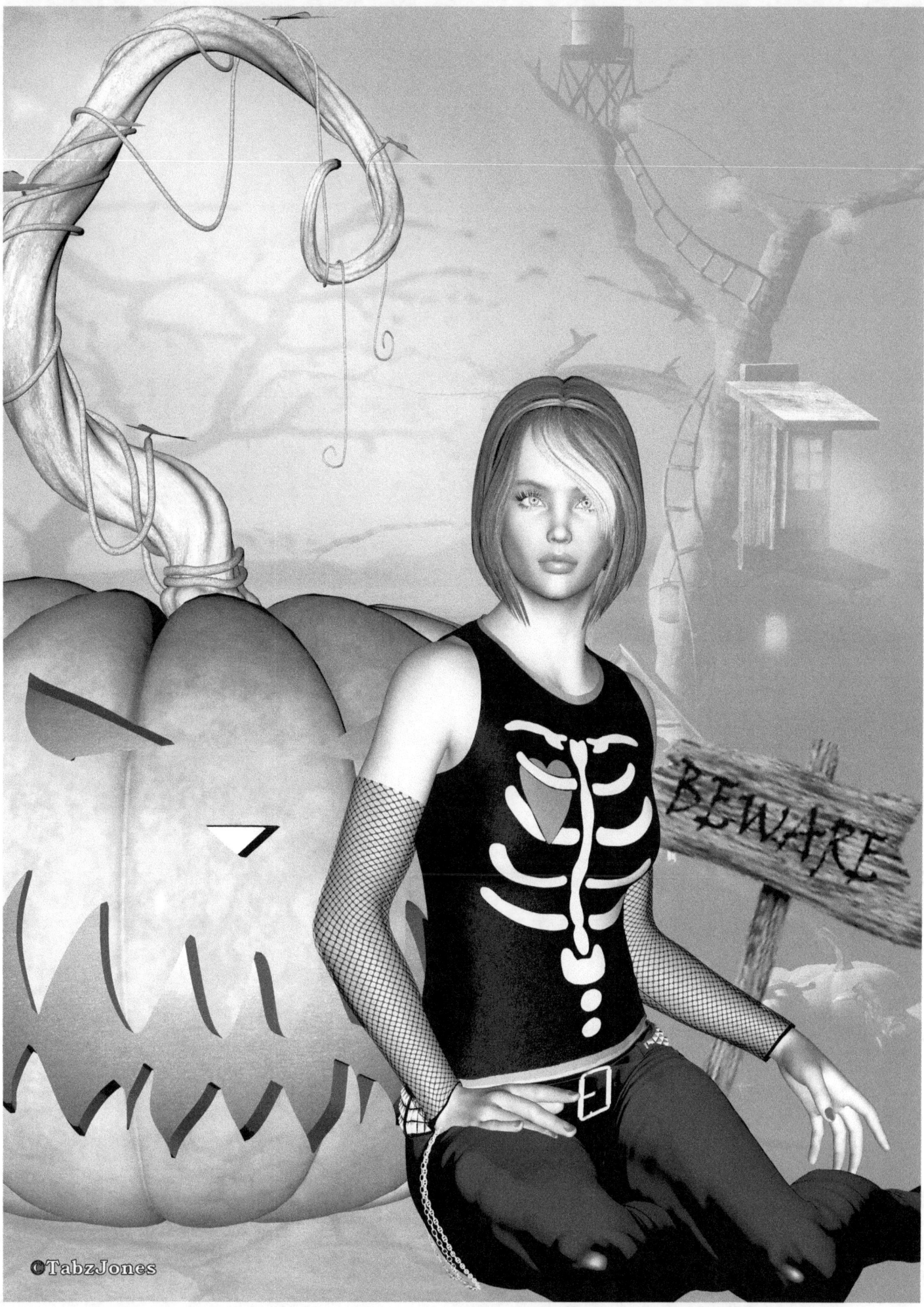

Happy Halloween
how many words can you make?

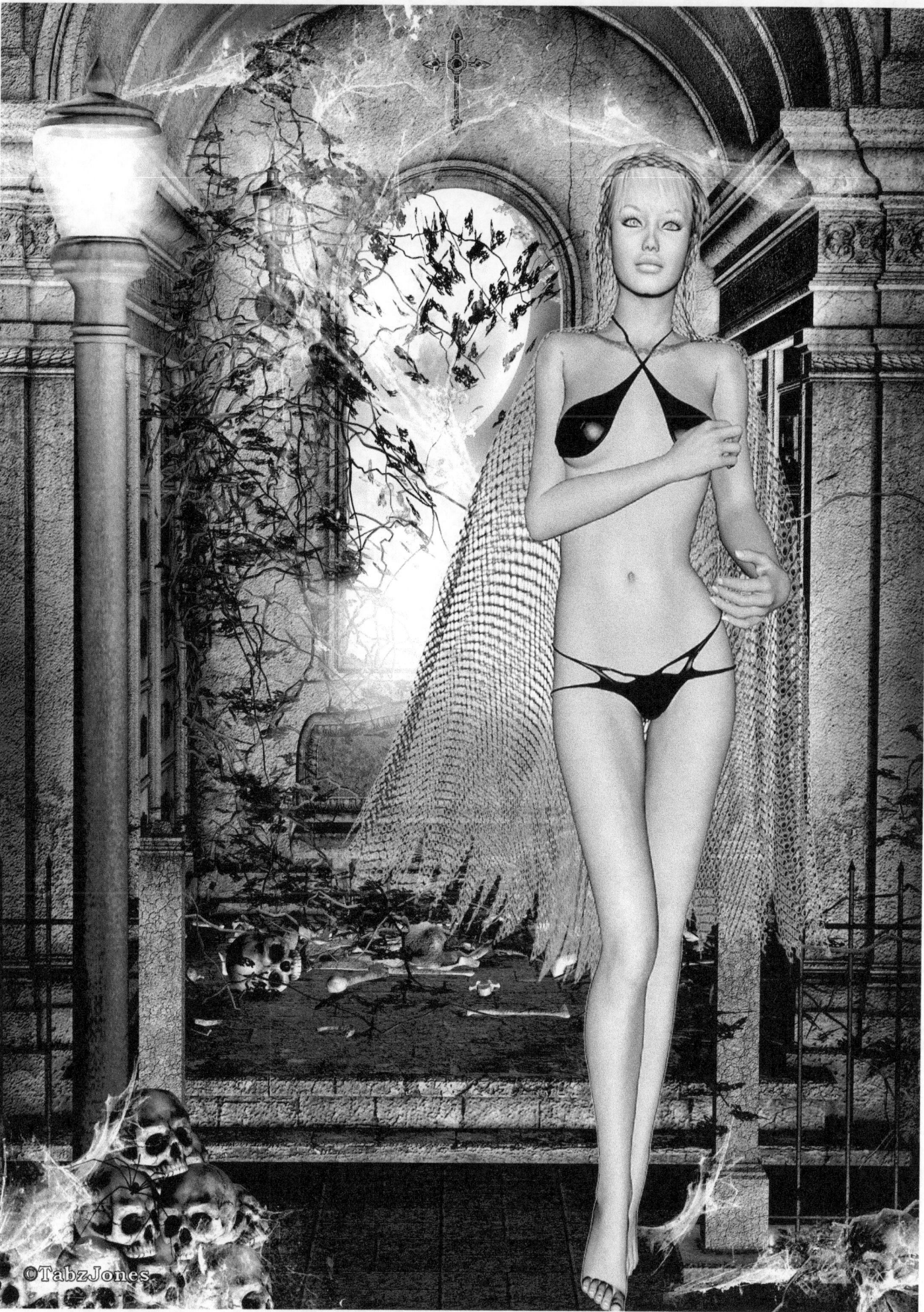

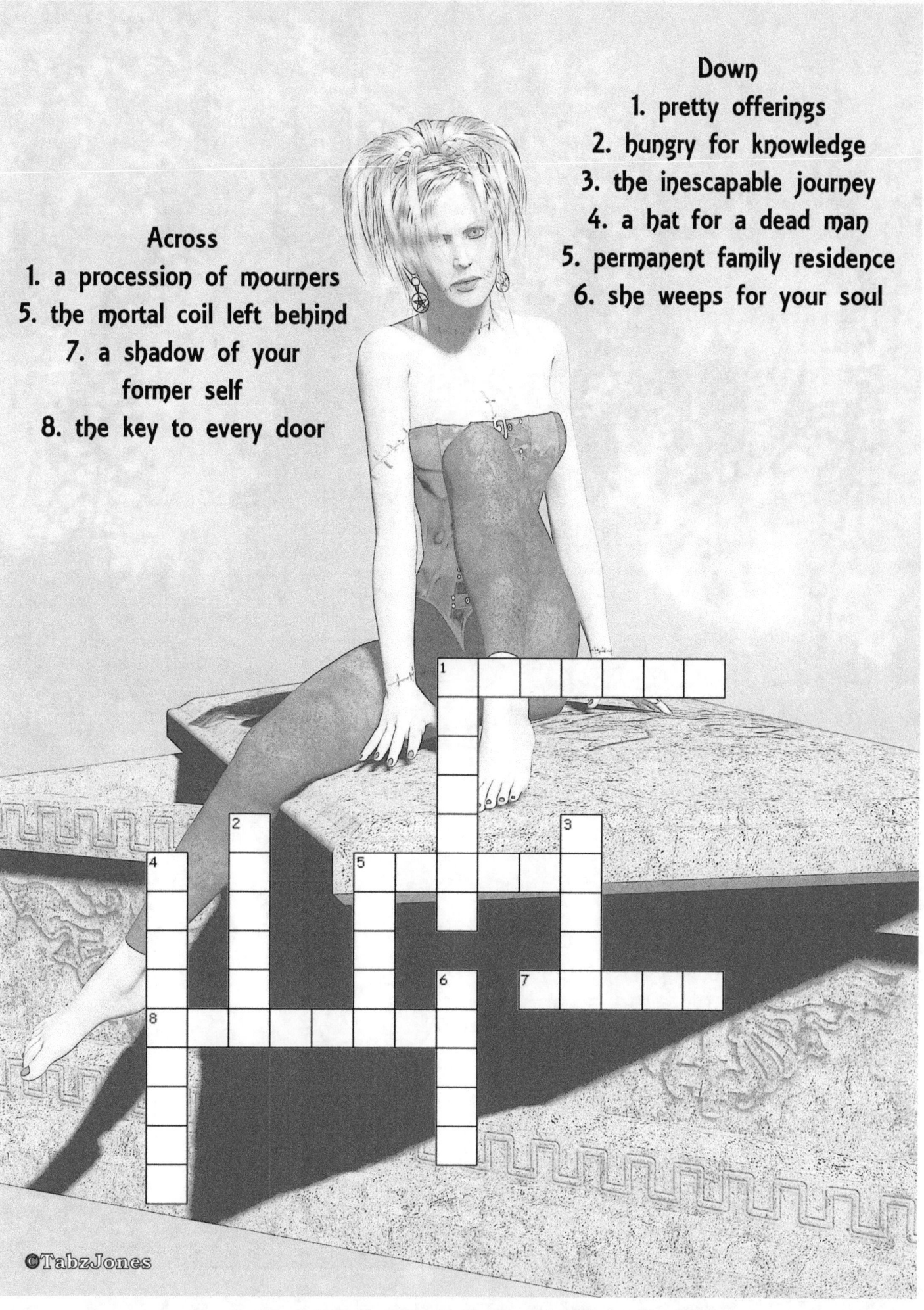

Across
1. a procession of mourners
5. the mortal coil left behind
7. a shadow of your former self
8. the key to every door

Down
1. pretty offerings
2. hungry for knowledge
3. the inescapable journey
4. a hat for a dead man
5. permanent family residence
6. she weeps for your soul

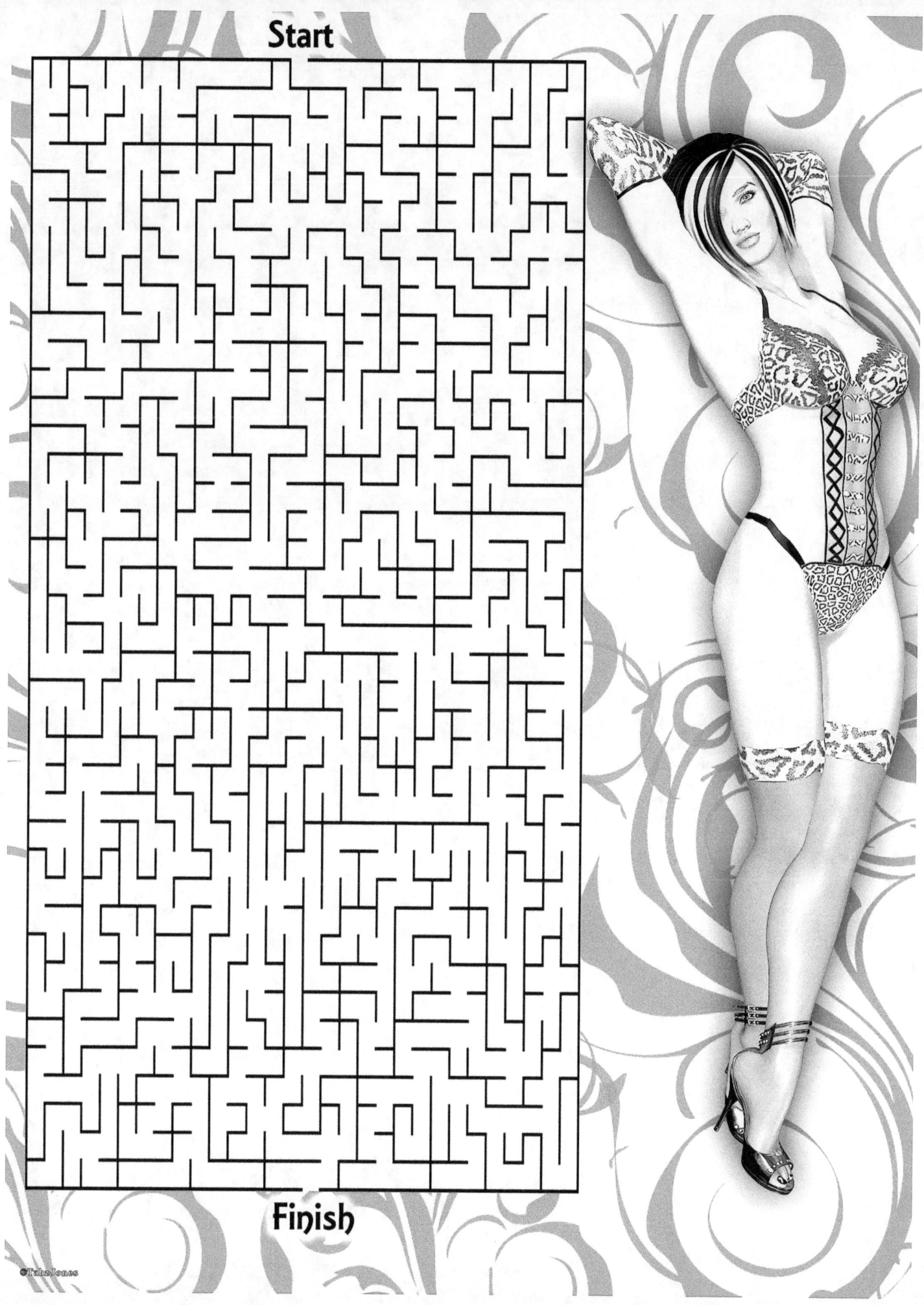

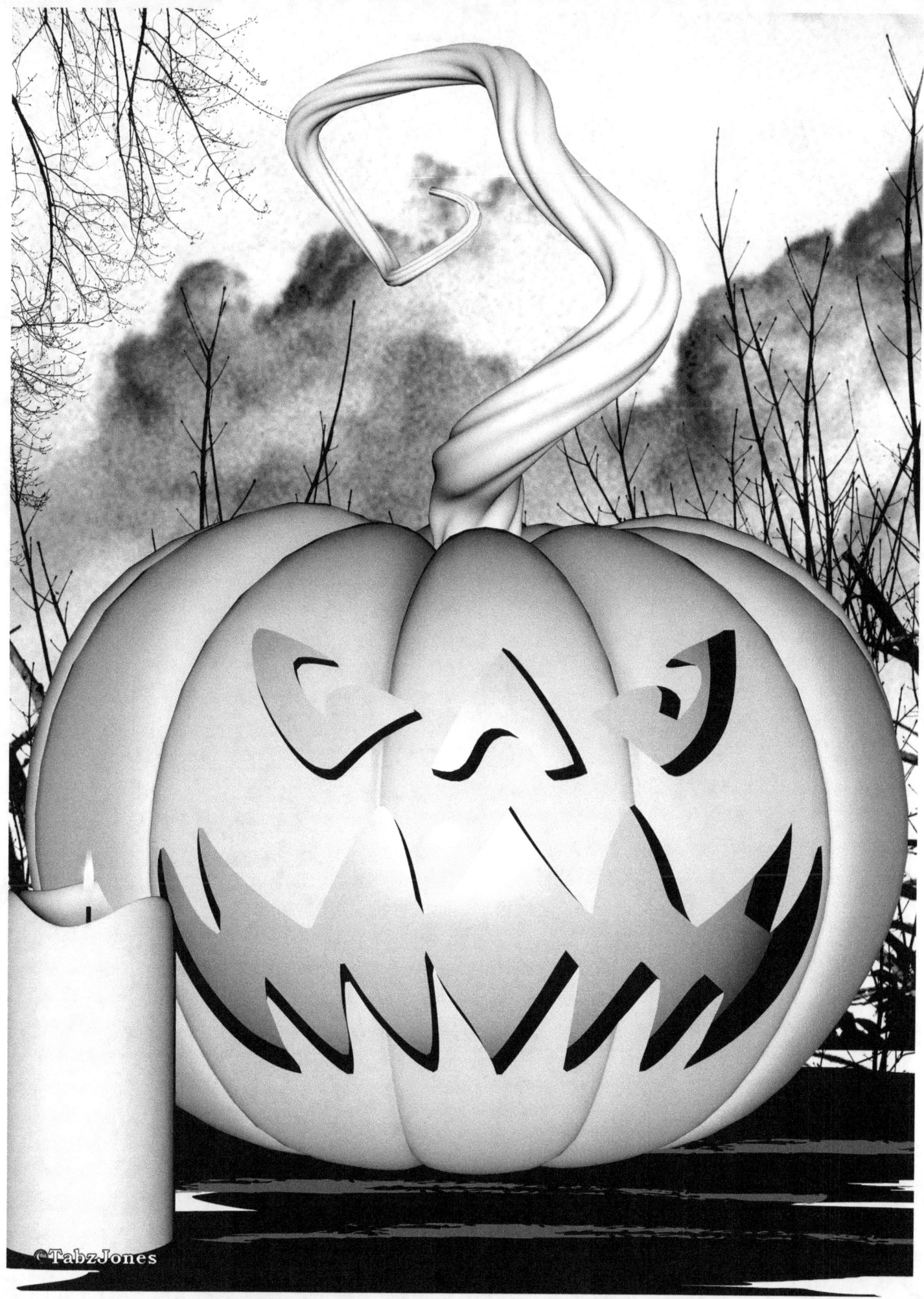

Dinner Time!

help the spider catch it's dinner

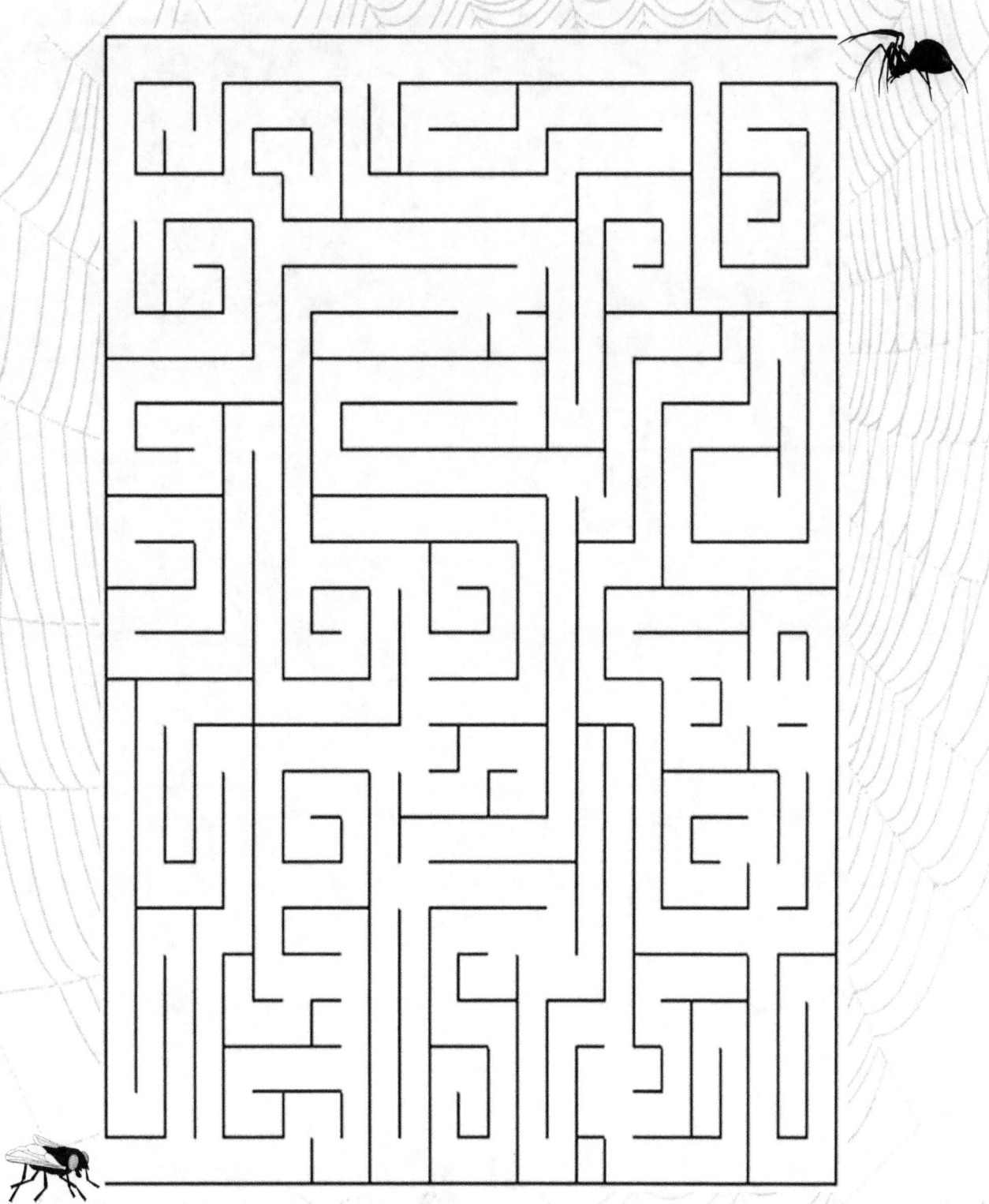

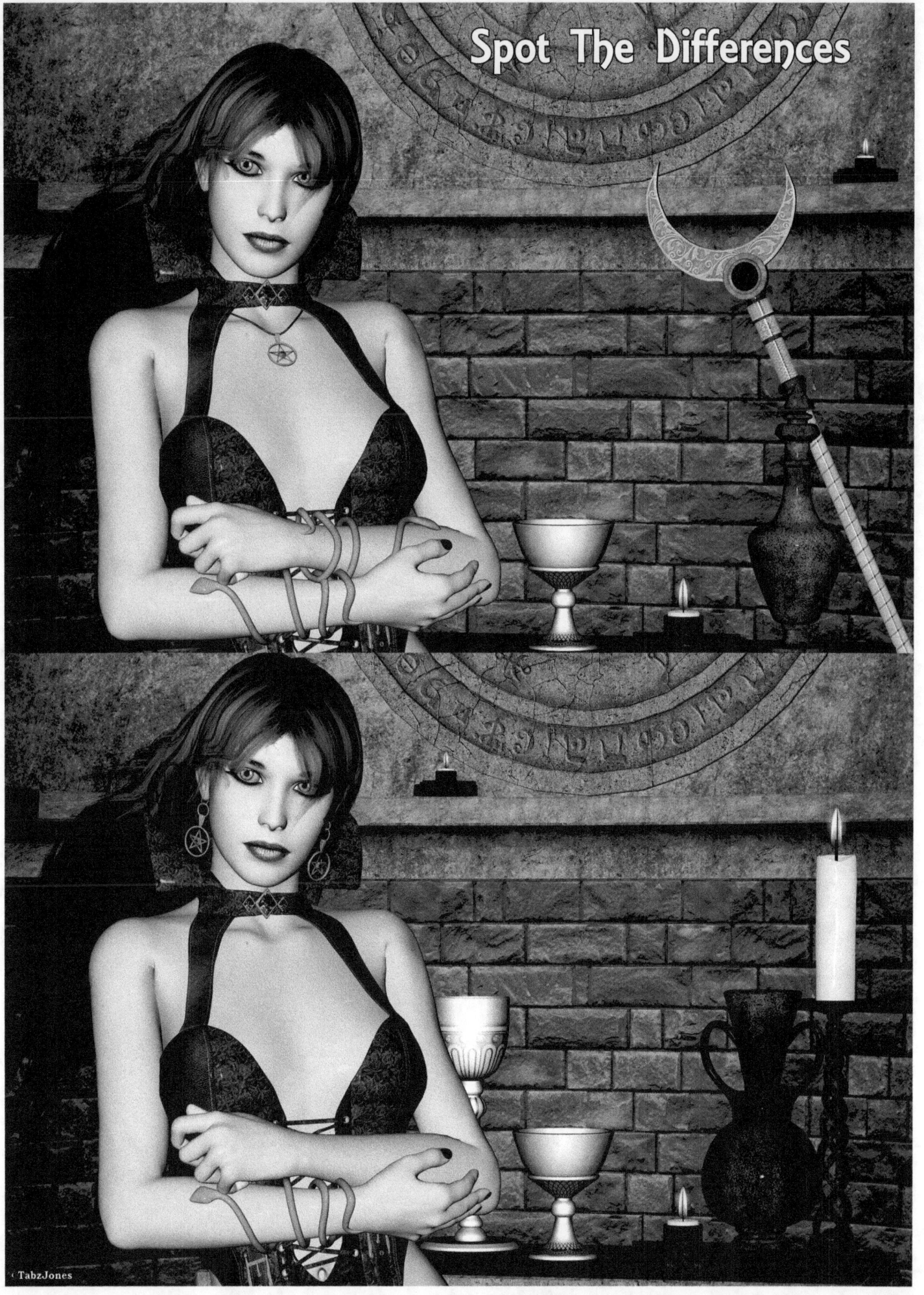

Ghosts, and goblins run the night,
Witches and werewolves hide from the light.
Vampires smile to see their prey,
Everybody come out and play.
The perfect night for those who wander
Forgotten souls have lots to ponder.
Foolish mortals pay no heed
And follow blindly where they lead.
My favorite night of all the year,
Knowing I have nothing to fear.
All of these are my kin
Though there are those who call it sin.
I'll run and play with those I love
And leave the worry to heaven above.
So come with me and we'll have some innocent fun
We've got all night, Happy Halloween everyone!

©TabzJones

Dinner Time!
help the spider catch it's dinner

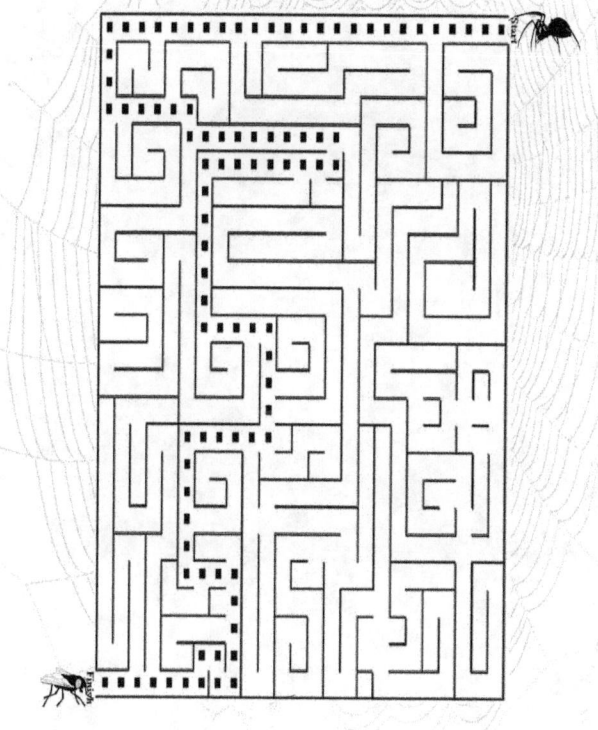

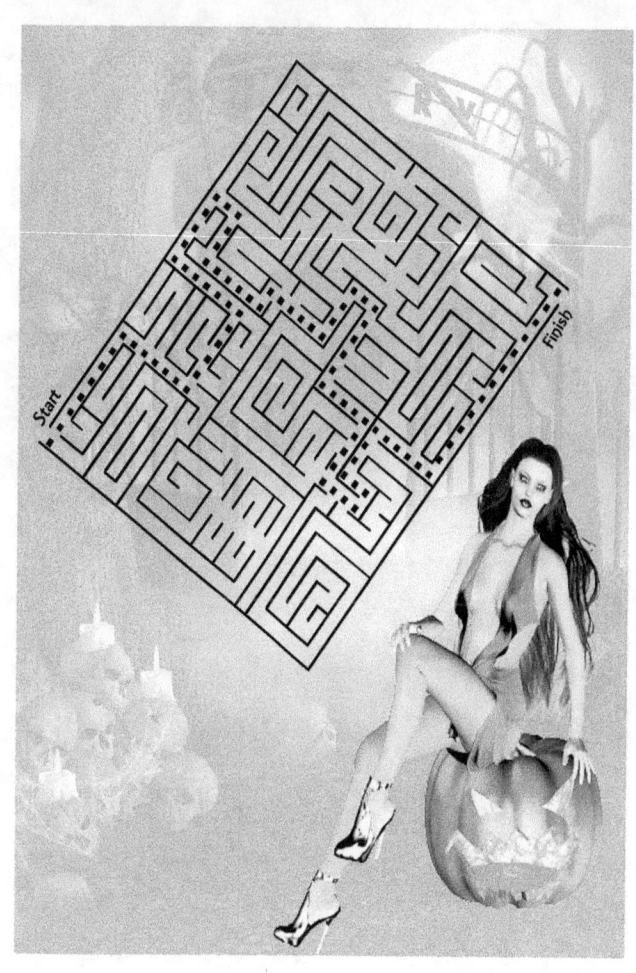

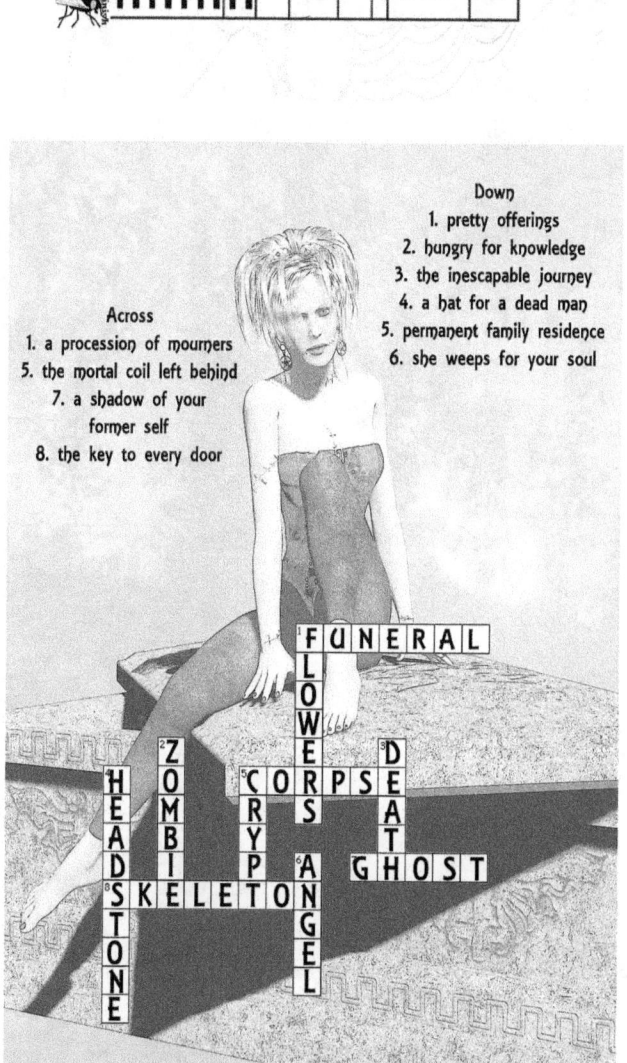

Across
1. a procession of mourners
5. the mortal coil left behind
7. a shadow of your former self
8. the key to every door

Down
1. pretty offerings
2. hungry for knowledge
3. the inescapable journey
4. a hat for a dead man
5. permanent family residence
6. she weeps for your soul

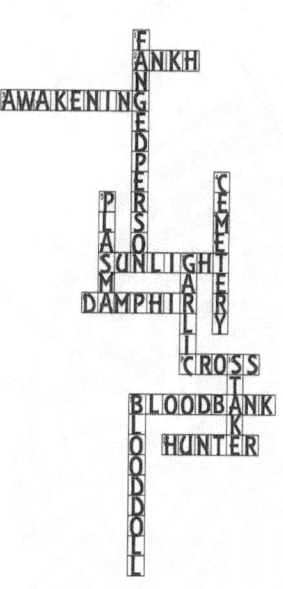

Across
2. symbol of eternal life
3. becoming a vampire
6. too hot to handle
8. half vampire half human
9. not a favorite accessory
11. a fast food restaurant
12. someone who kills vampires

Down
1. a vampire
4. where to find a vampire
5. white wine to a vampire
7. totally allergic to this
10. how to kill a vampire
11. a vampire's girlfriend

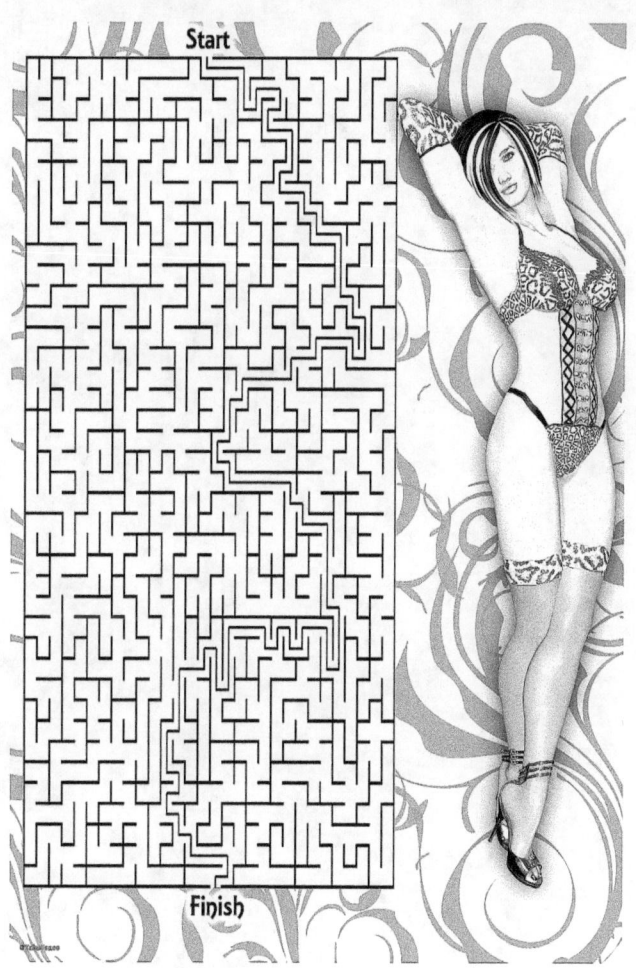

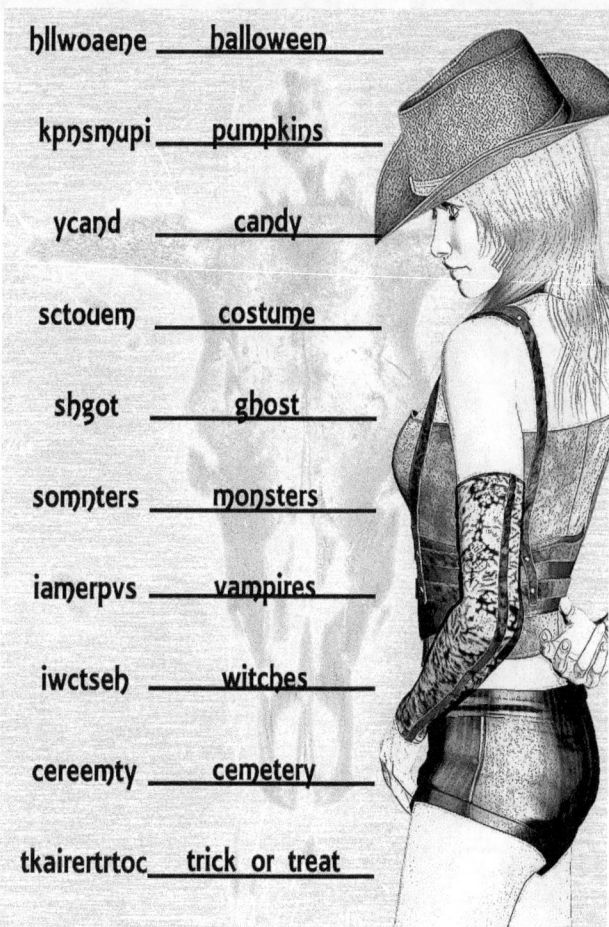

hllwoaene	halloween	
kpnsmupi	pumpkins	
ycand	candy	
sctouem	costume	
shgot	ghost	
somnters	monsters	
iamerpvs	vampires	
iwctseh	witches	
cereemty	cemetery	
tkairertrtoc	trick or treat	

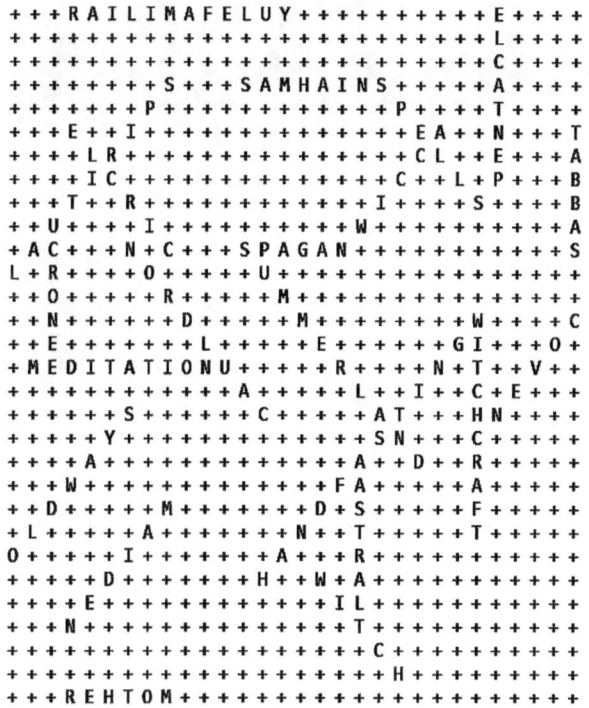

Witchy Ways

ASTRAL · MAIDEN · SPELLS
CAULDRON · MEDITATION · SPIRITUAL
CIRCLE · MOTHER · SUMMERLAND
COVEN · OLDWAYS · WICCA
CRONE · PAGAN · WITCH
FAMILIAR · PENTACLE · WITCHCRAFT
HANDFASTING · SABBAT · YULE
· SAMHAIN ·

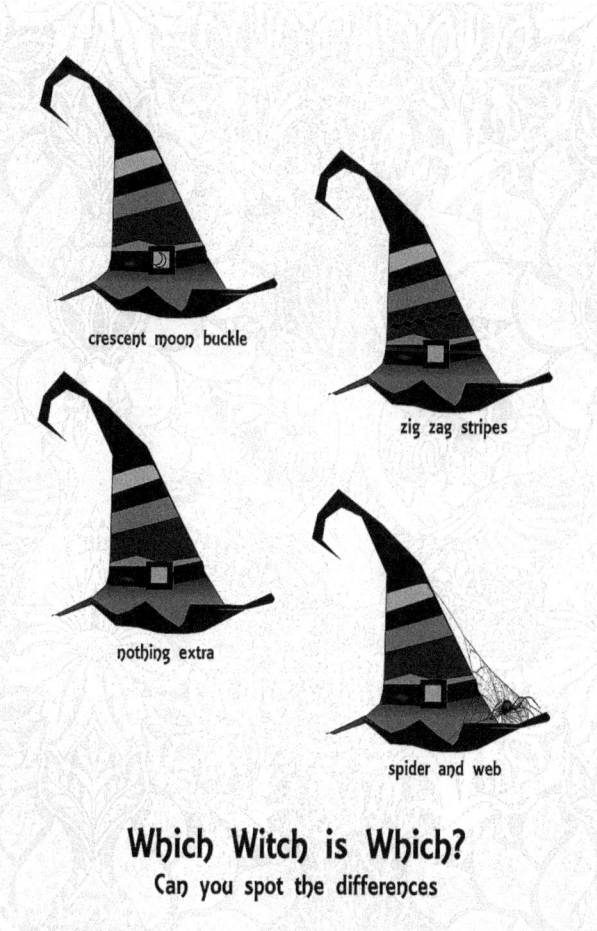

crescent moon buckle

zig zag stripes

nothing extra

spider and web

Which Witch is Which?
Can you spot the differences

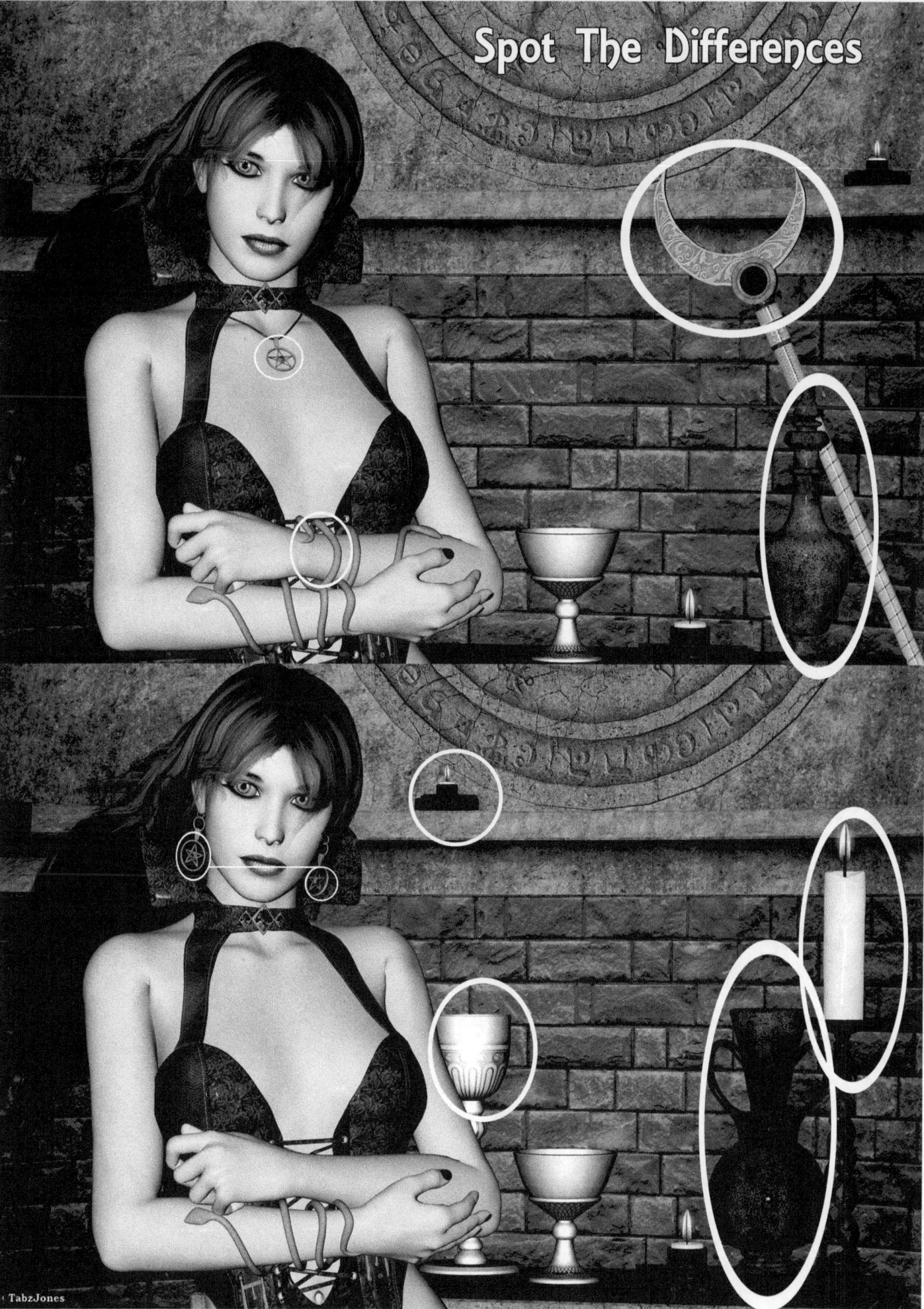

Thank you for your purchase!

To see the full catalog of my art, don't forget to stop by
www.gothictoggs.net

www.ingramcontent.com/pod-product-compliance
Lightning Source LLC
Chambersburg PA
CBHW080547190526

45169CB00007B/2667